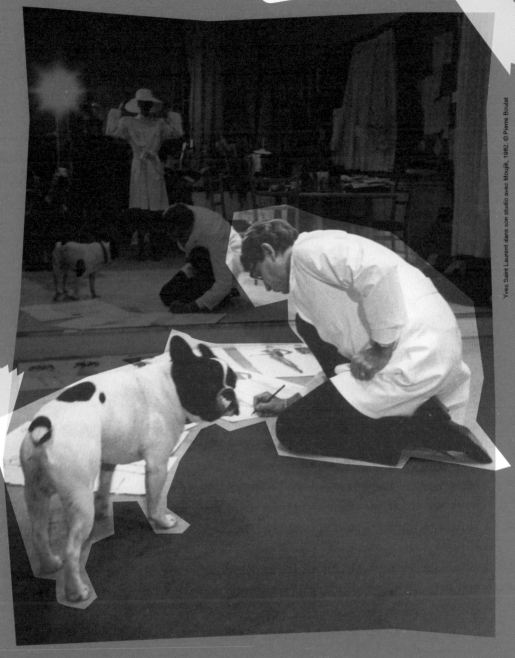

Yves Saint Laurent
and his dog Moujik

ARSENAL PULP PRESS
#202–211 East Georgia Street
Vancouver, BC V6A 1Z6
Canada
arsenalpulp.com

This book is produced with the co–operation of Fondation Pierre Bergé – Yves Saint Laurent.

Title page image: Yves Saint Laurent by Bernard Buffet, 1958. © Fondation Pierre Bergé – Yves Saint Laurent

Printed in Korea

Canadian Cataloguing in Publication Data available upon request

Yves Saint Laurent
COLORING
BOOK

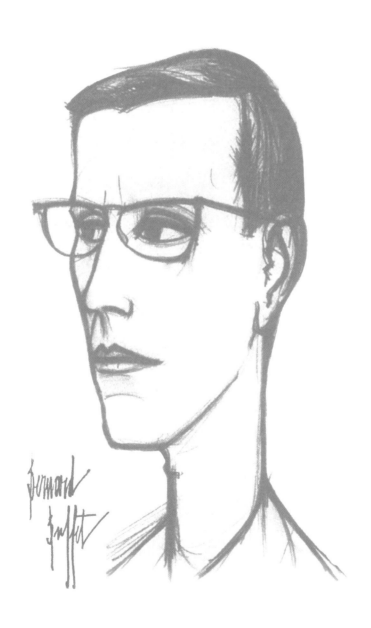

ARSENAL
PULP PRESS

This coloring book is a tribute to some of Yves Saint Laurent's best known haute couture designs — an invitation for us to discover the world of extraordinary shapes, textures, and colors of this immensely talented fashion artist, one of the greatest designers of the twentieth century.

Through many of his designs, Saint Laurent takes us on imaginary journeys to Spain, Russia, Africa, and Asia. Other designs evoke his passion for art, in particular the work of Picasso, Léger, and Renoir, artists whom he paid tribute to throughout his career.

His designs also reveal his love of the entertainment world, as evidenced in his costumes for theatre, ballet, music hall, and cinema.

This book lets young people and adults alike to explore the creative and revolutionary world of Yves Saint Laurent.

— Fondation Pierre Bergé – Yves Saint Laurent

EXTRAORDINARY TRAVELS

"A good garment is a passport to happiness."

Yves Saint Laurent

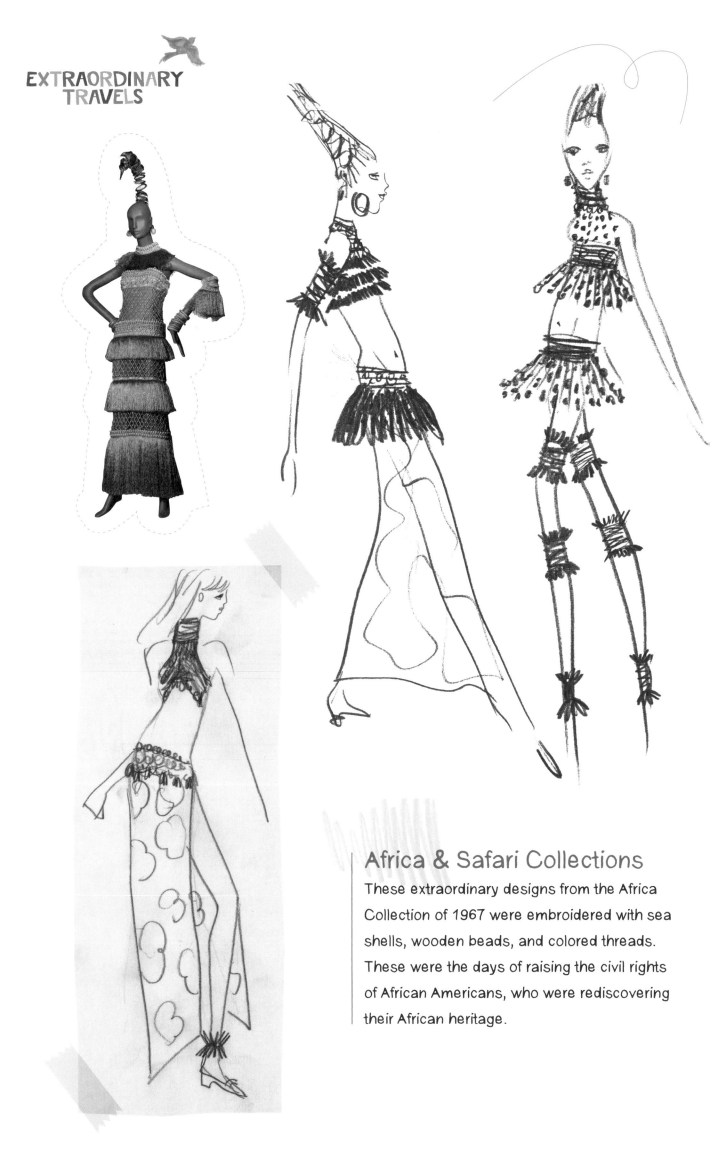

EXTRAORDINARY TRAVELS

Africa & Safari Collections

These extraordinary designs from the Africa Collection of 1967 were embroidered with sea shells, wooden beads, and colored threads. These were the days of raising the civil rights of African Americans, who were rediscovering their African heritage.

AFRICA

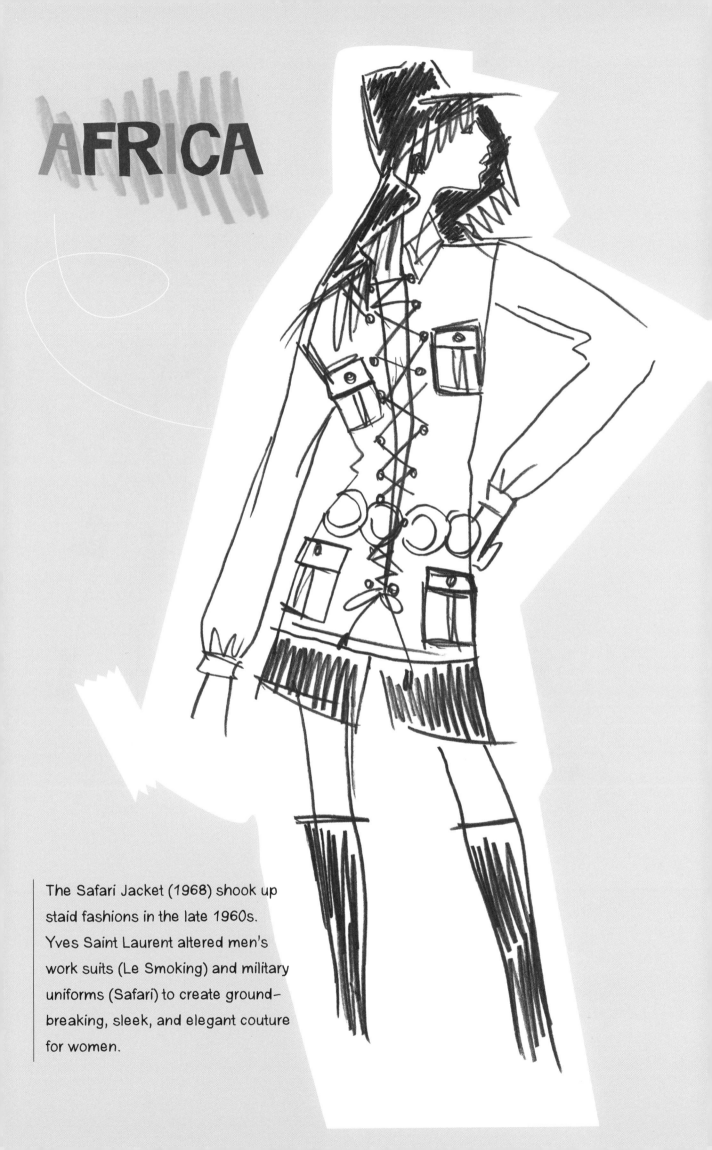

The Safari Jacket (1968) shook up staid fashions in the late 1960s. Yves Saint Laurent altered men's work suits (Le Smoking) and military uniforms (Safari) to create groundbreaking, sleek, and elegant couture for women.

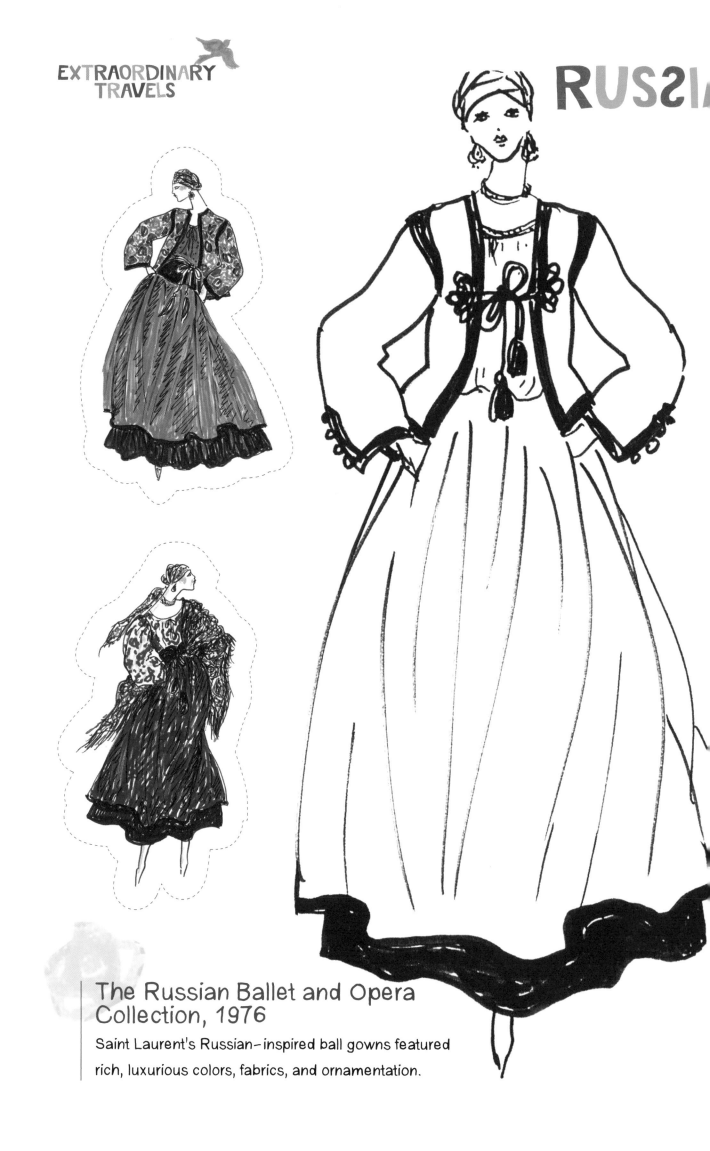

The Russian Ballet and Opera Collection, 1976

Saint Laurent's Russian-inspired ball gowns featured rich, luxurious colors, fabrics, and ornamentation.

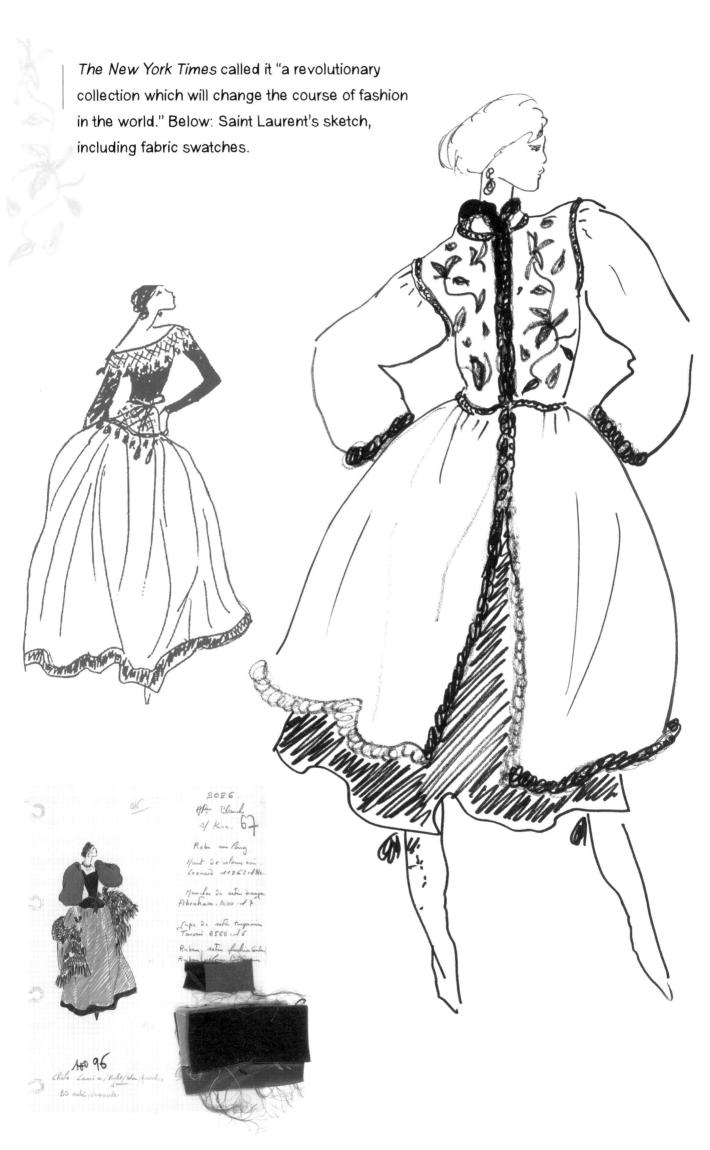

The New York Times called it "a revolutionary collection which will change the course of fashion in the world." Below: Saint Laurent's sketch, including fabric swatches.

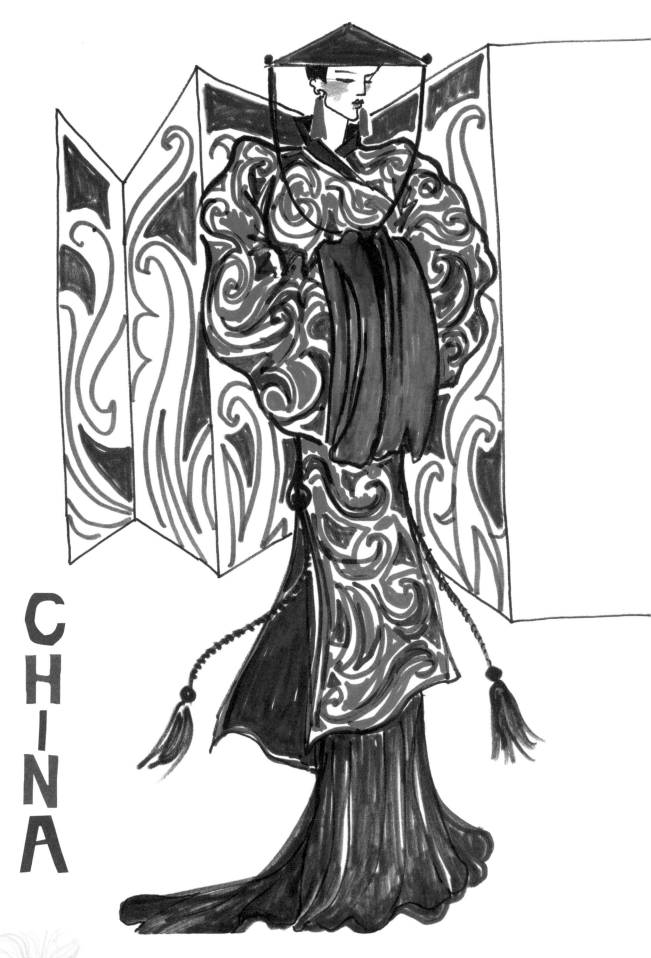

CHINA

The Chinese and Opium Collection, 1977

This collection featured damask, embroidered velvet, and satin crepe dresses, combining authentic and imaginary elements of Chinese clothing.

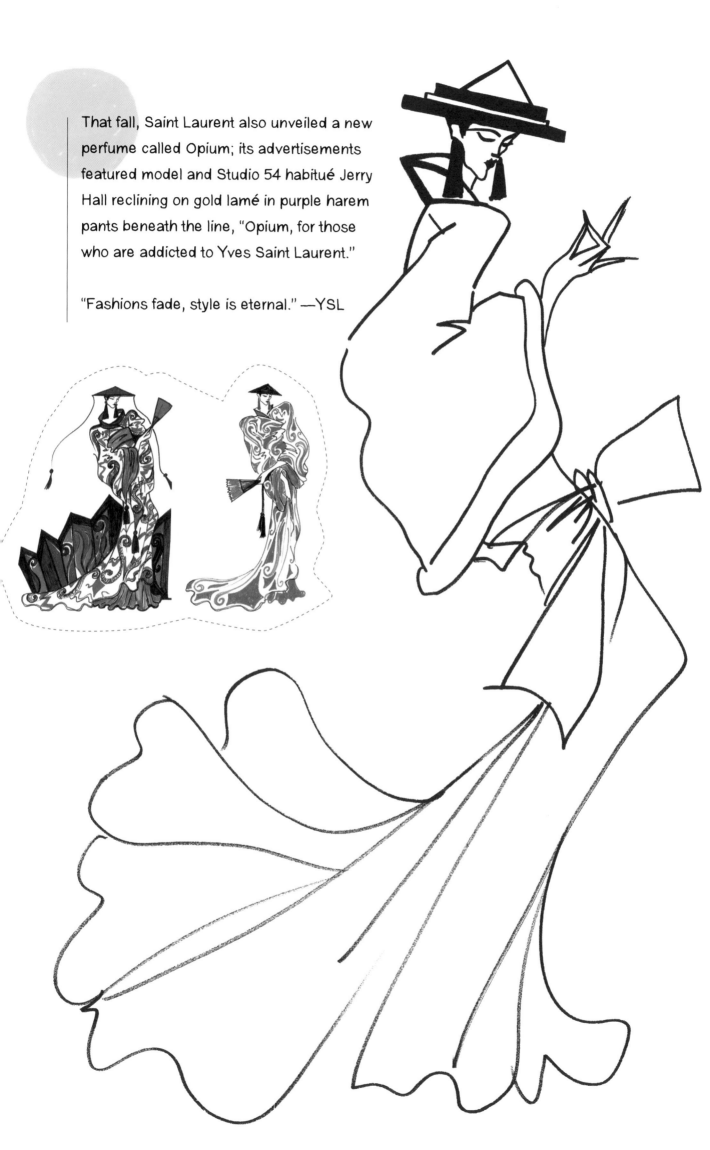

That fall, Saint Laurent also unveiled a new perfume called Opium; its advertisements featured model and Studio 54 habitué Jerry Hall reclining on gold lamé in purple harem pants beneath the line, "Opium, for those who are addicted to Yves Saint Laurent."

"Fashions fade, style is eternal." —YSL

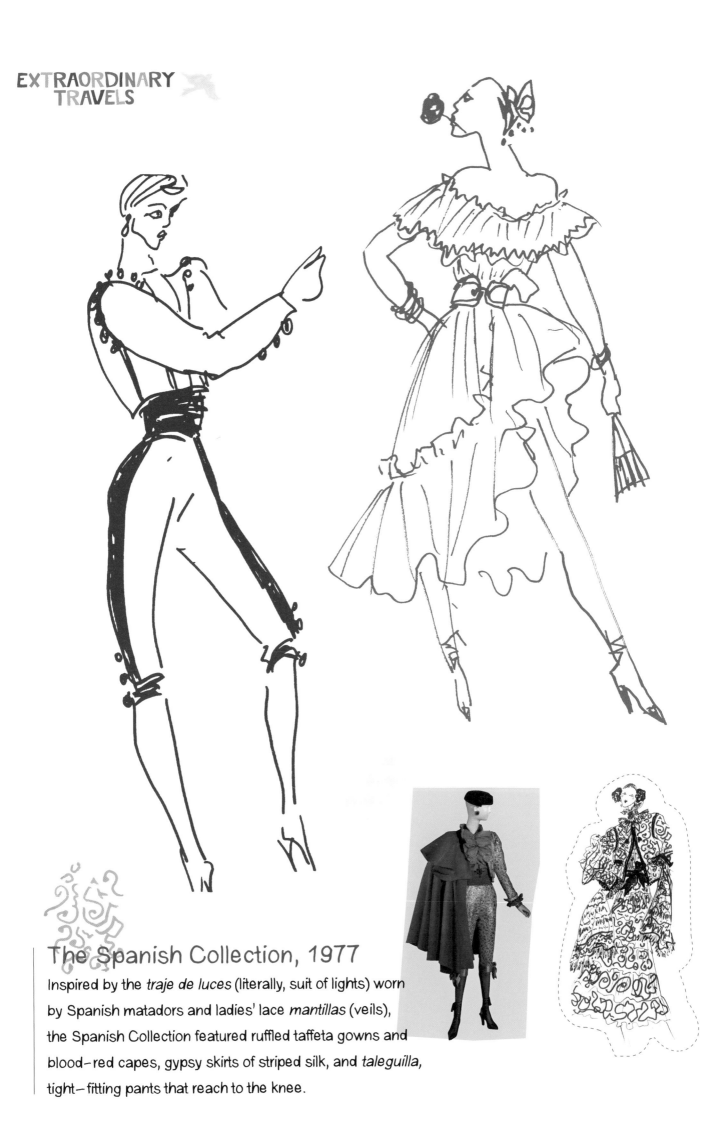

The Spanish Collection, 1977

Inspired by the *traje de luces* (literally, suit of lights) worn
by Spanish matadors and ladies' lace *mantillas* (veils),
the Spanish Collection featured ruffled taffeta gowns and
blood-red capes, gypsy skirts of striped silk, and *taleguilla*,
tight-fitting pants that reach to the knee.

SPAIN

"Over the years, I have learned that what is important in a dress is the woman who is wearing it."

Yves Saint Laurent

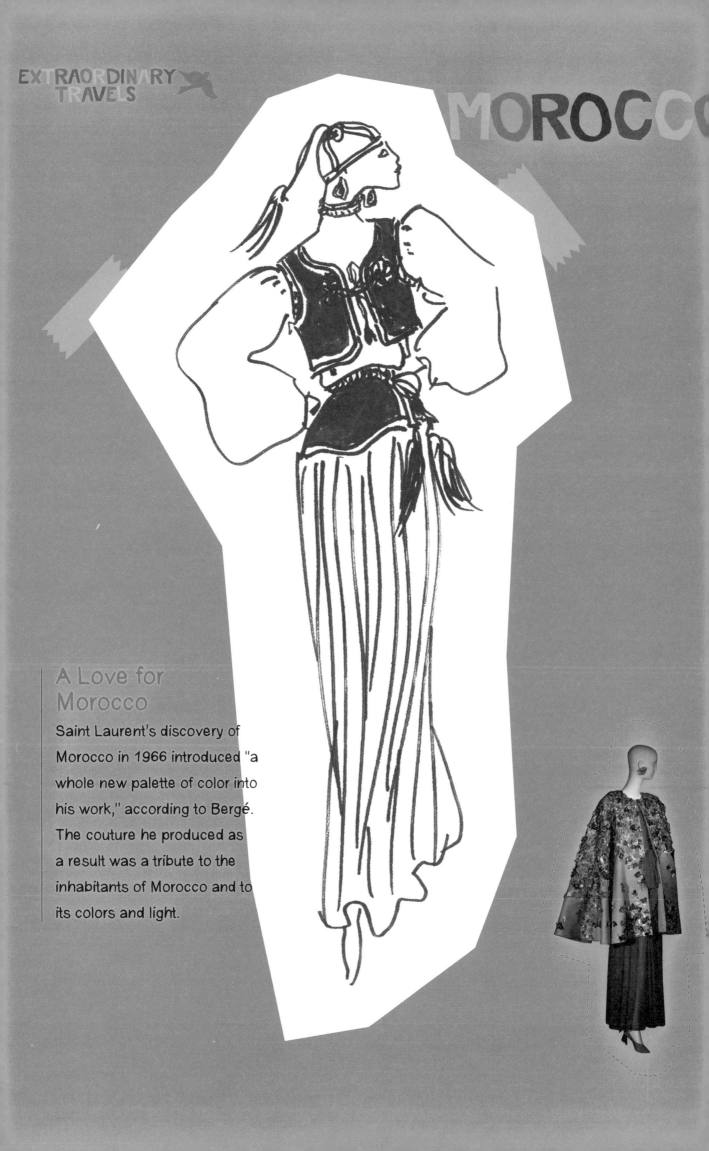

A Love for Morocco

Saint Laurent's discovery of Morocco in 1966 introduced "a whole new palette of color into his work," according to Bergé. The couture he produced as a result was a tribute to the inhabitants of Morocco and to its colors and light.

Morocco is a recurrent theme in YSL collections. He and his partner Pierre Bergé bought three homes there, as well as the Majorelle garden, and considered it their adopted country and second homeland. YSL's ashes are scattered in the garden of his home in Marrakesh.

The clothes were influenced by North African geometric pottery, henna and tattoo patterns, djebellas, fez-like hats, harem pants, and dresses adorned with flowers found in YSL's Marrakesh gardens.

Can you replicate one of the designs at right?

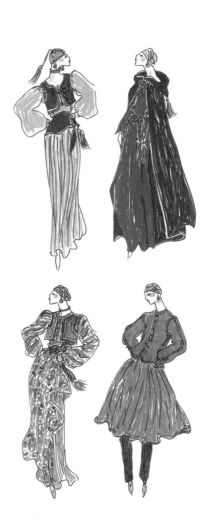

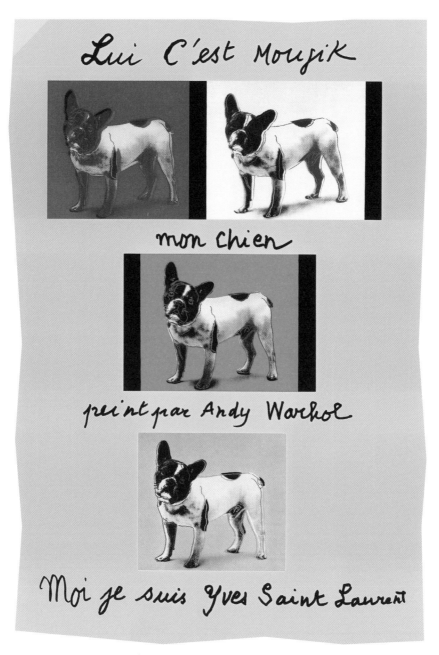

Lui C'est Moujik

mon chien

peint par Andy Warhol

Moi je suis Yves Saint Laurent

A YSL greeting card from 1991:
"Him? That's Moujik, my dog, as painted by Andy Warhol. And me? I'm Yves Saint Laurent."

YSL AND ART

"I tried to show that fashion is art."

Yves Saint Laurent

The Mondrian Dress, 1965

Piet Mondrian's instantly recognizable abstract geometric paintings were created with black and white and pure primary colors – yellow, blue, and red.

"Mondrian is purity ... a purity that joins with that of the Bauhaus. The masterpiece of the twentieth century is a Mondrian." —YSL

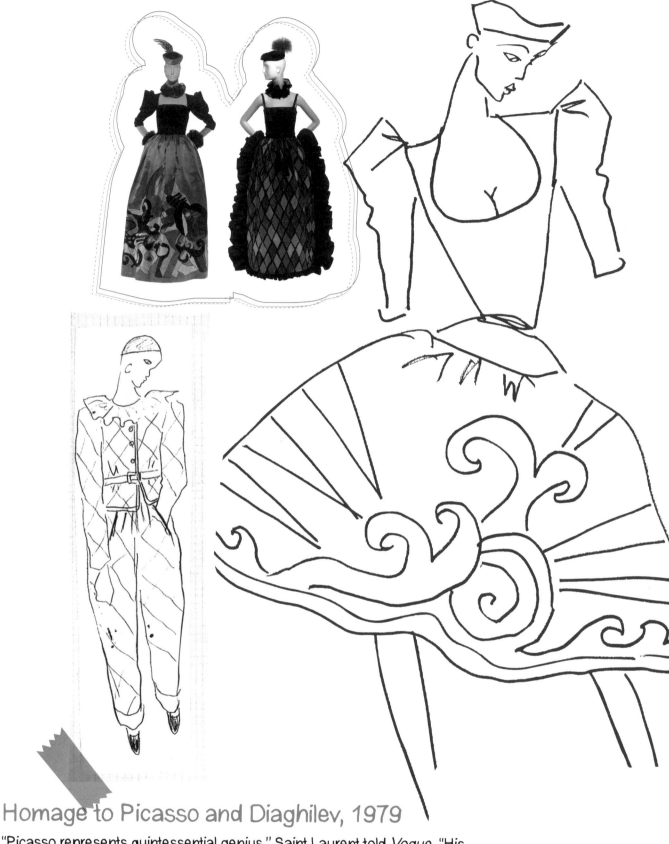

Homage to Picasso and Diaghilev, 1979

"Picasso represents quintessential genius," Saint Laurent told *Vogue*. "His work explodes with life and honesty. Picasso is not purity. He's baroque."

Sergei Diaghilev, the early 20th-century impresario, art critic and patron, was the founder of the radically inventive and influential Ballets Russes.

The collection featured suede patchwork jackets and dresses made of velvet, taffeta, tulle, and moire.

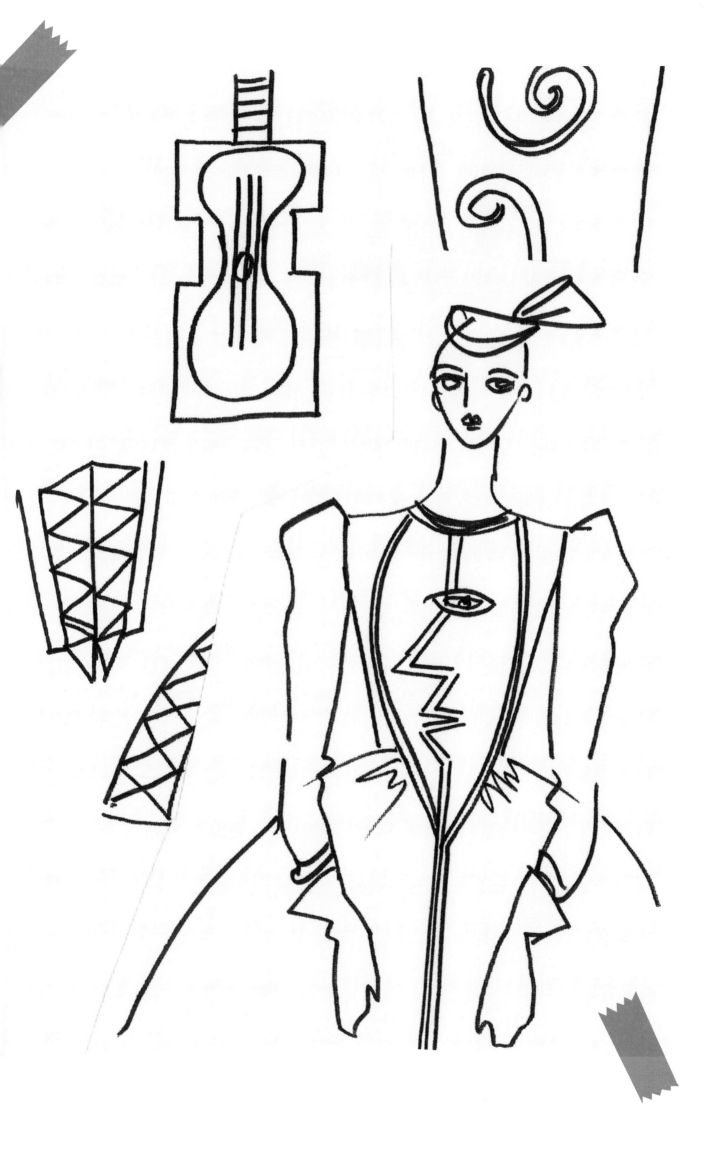

YSL AND ART

Marrakech

Canard

Matelot

Poppen

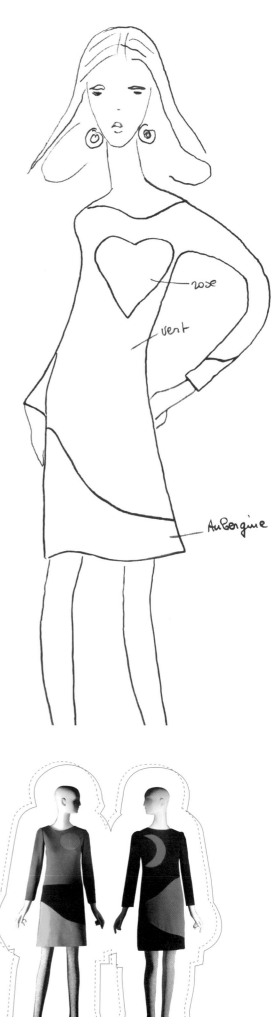

rose

vert

Aubergine

Pop Art, 1966

Inspired by Andy Warhol (who painted Saint Laurent's portrait in 1972 and his dog Moujik in 1986), the Pop Art dresses showcased images of the heart, the sun, the moon, as well as the human face and body on jersey mini-dresses.

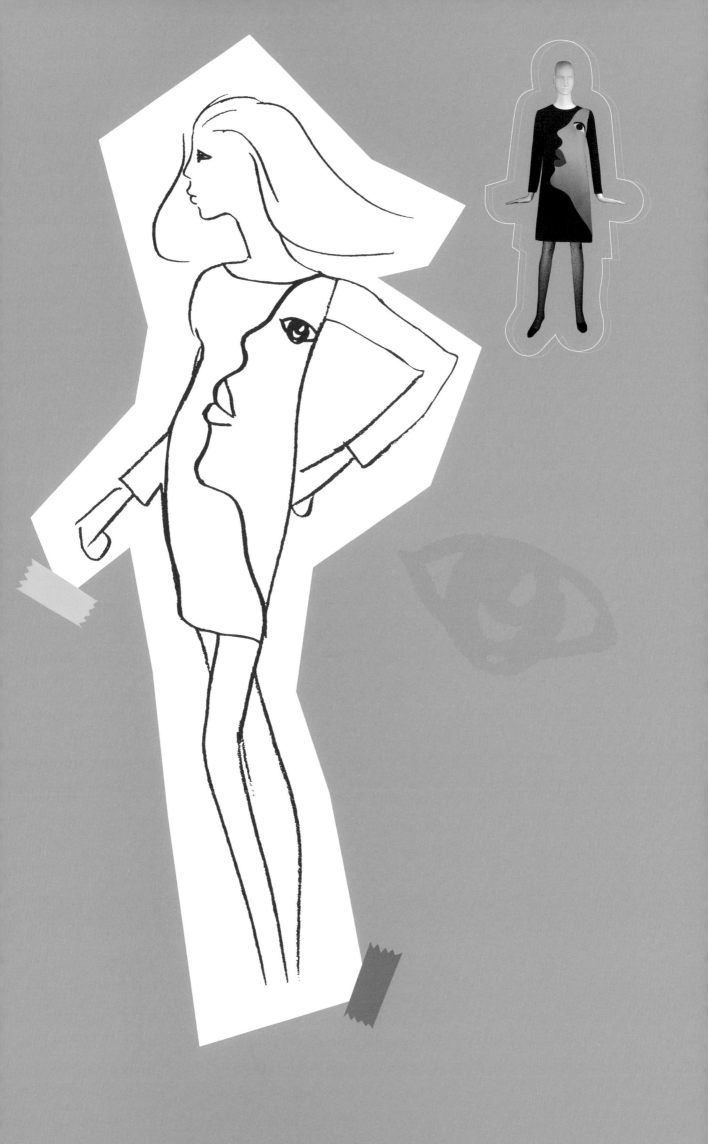

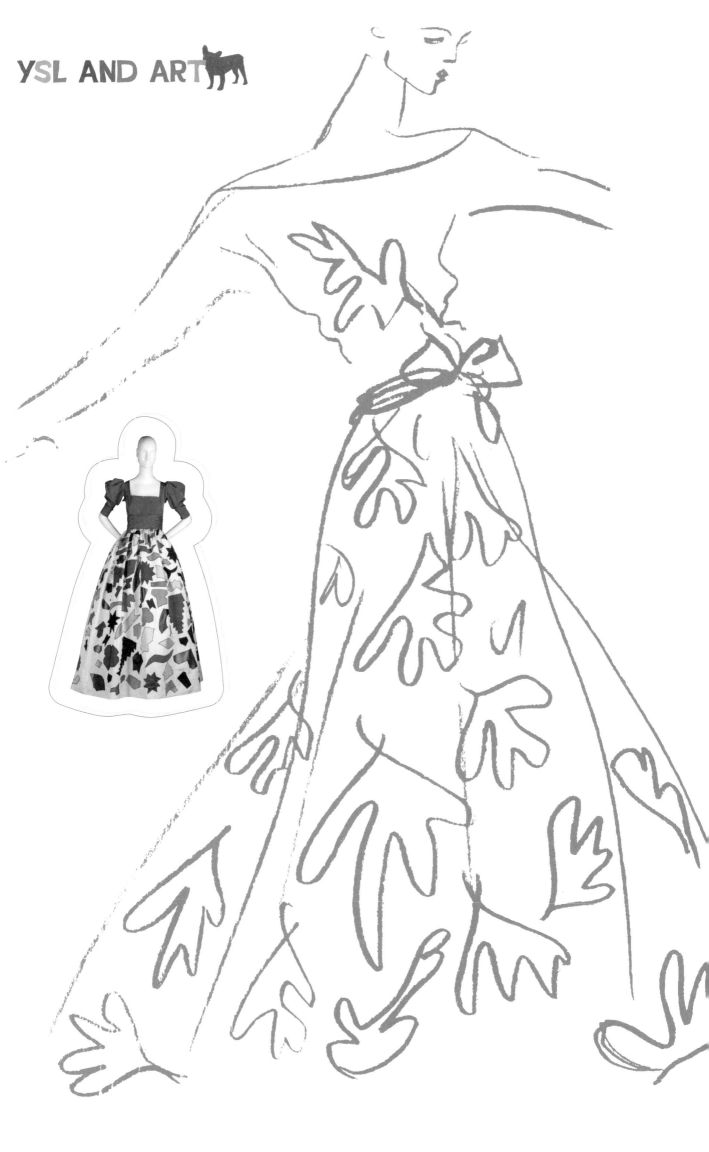

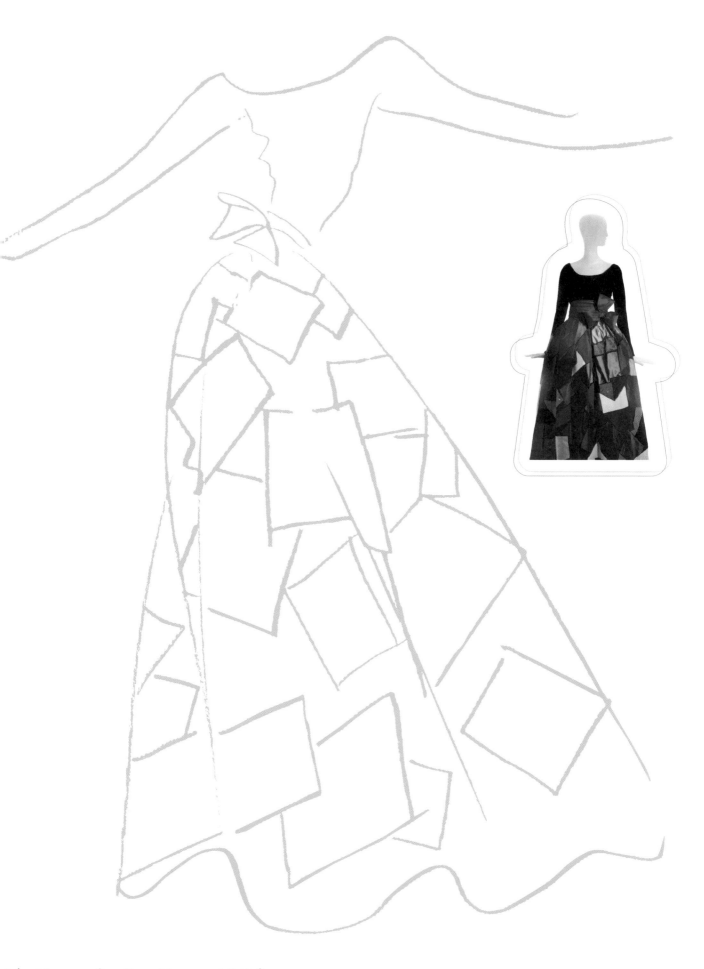

Matisse Collection, 1980

Henri Matisse's famous "cutouts" are referenced in Saint Laurent's homage to the French post-Impressionists, whose work he also collected. These gowns were created from black velvet and moire faille with multi-colored silk appliqué.

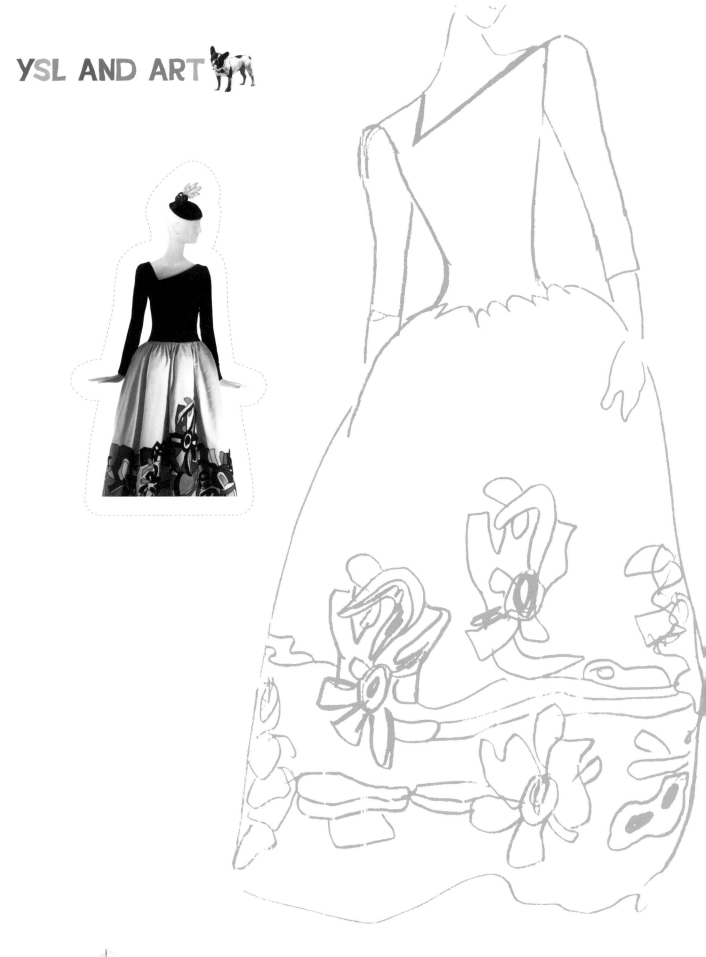

Homage to Léger, 1981

Early 20th-century French avant-garde painter Fernand Léger's works are distinguished by a focus on cylindrical forms and robot-like human figures.

This long evening dress, made in tribute to Léger for the Fall–Winter 1981 Collection, has a black velvet top, white satin skirt, and multi–colored appliqué patchwork.

Love Me Forever, 1970

Embroidered with the words "Love Me Forever or Never," this multi-colored velvet bridal coat was a playful alternative to the traditional white wedding gown.

"The most beautiful clothes that can dress a woman are the arms of the man she loves. But for those who haven't had the fortune of finding this happiness, I am there." —YSL

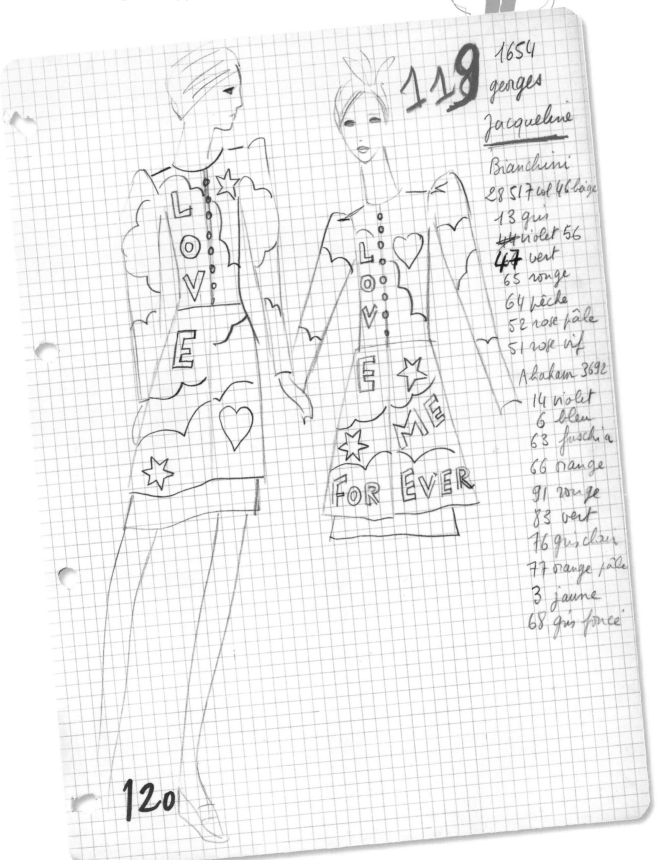

1654
georges
Jacqueline

Bianchini
28 517 col 46 beige
13 gris
violet 56
47 vert
65 rouge
64 pêche
52 rose pâle
51 rose vif

Abraham 3692
14 violet
6 bleu
63 fuschia
66 orange
91 rouge
83 vert
76 gris clair
77 orange pâle
3 jaune
68 gris foncé

118

120

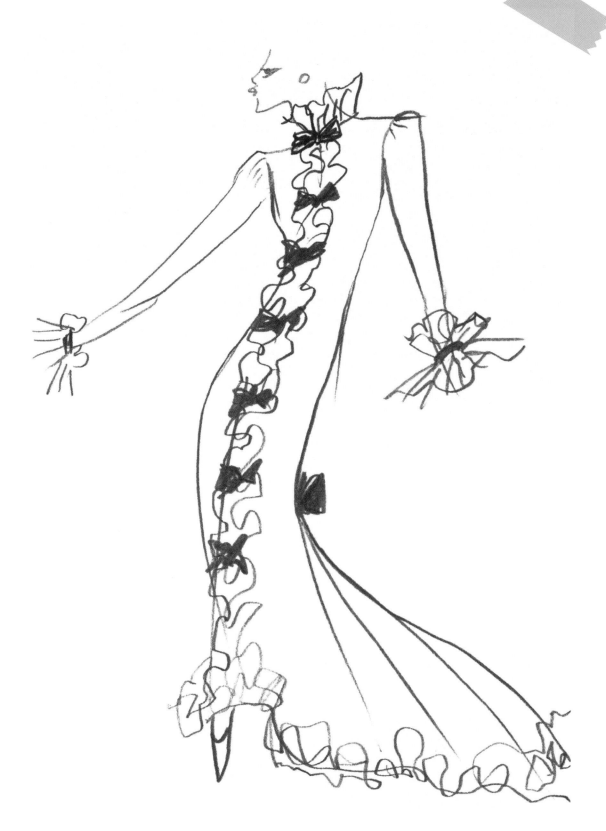

Homage to Renoir

This wedding dress was inspired by 19th-century Impressionist Auguste Renoir, whose paintings often featured women in diaphanous ruffled gowns. Renoir had a couturier's appreciation for fine fabric: his father was a tailor, his mother a dressmaker.

This YSL dress may have been inspired by *Portrait of Madame Charpentier and Her Children* (187

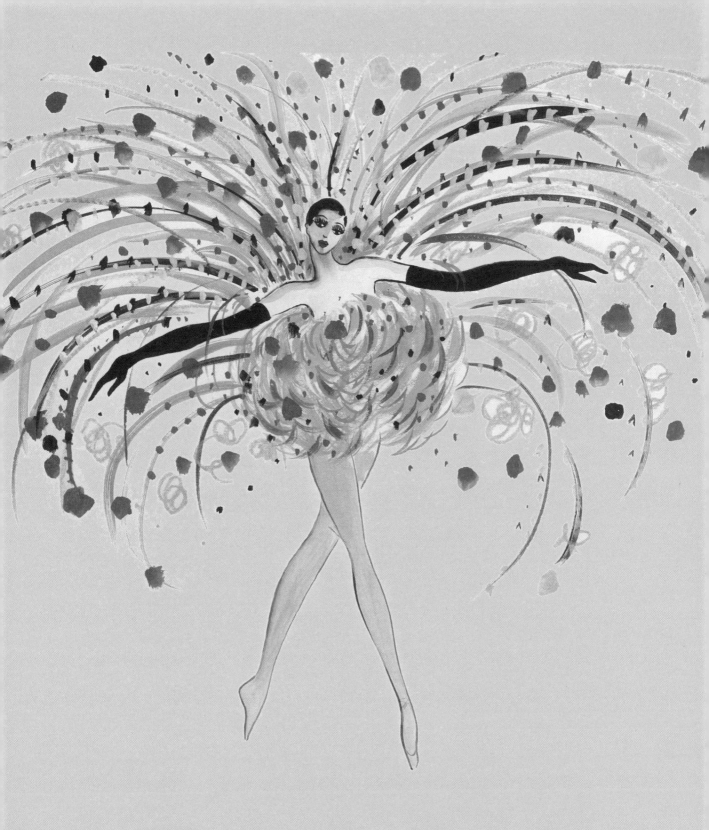

IN THE LIMELIGHT

"To dress up is to get ready to play a part."

Yves Saint Laurent

IN THE LIMELIGHT

● Venice

These Domino costumes, evoking the masked balls of Renaissance Venice, were created by Saint Laurent in 1972 for a music hall performance of *Zizi, je t'aime* (music by Serge Gainsbourg) at Casino de Paris starring ballet dancer Zizi Jeanmaire, whom Saint Laurent met at the house of Dior in the 1960s.

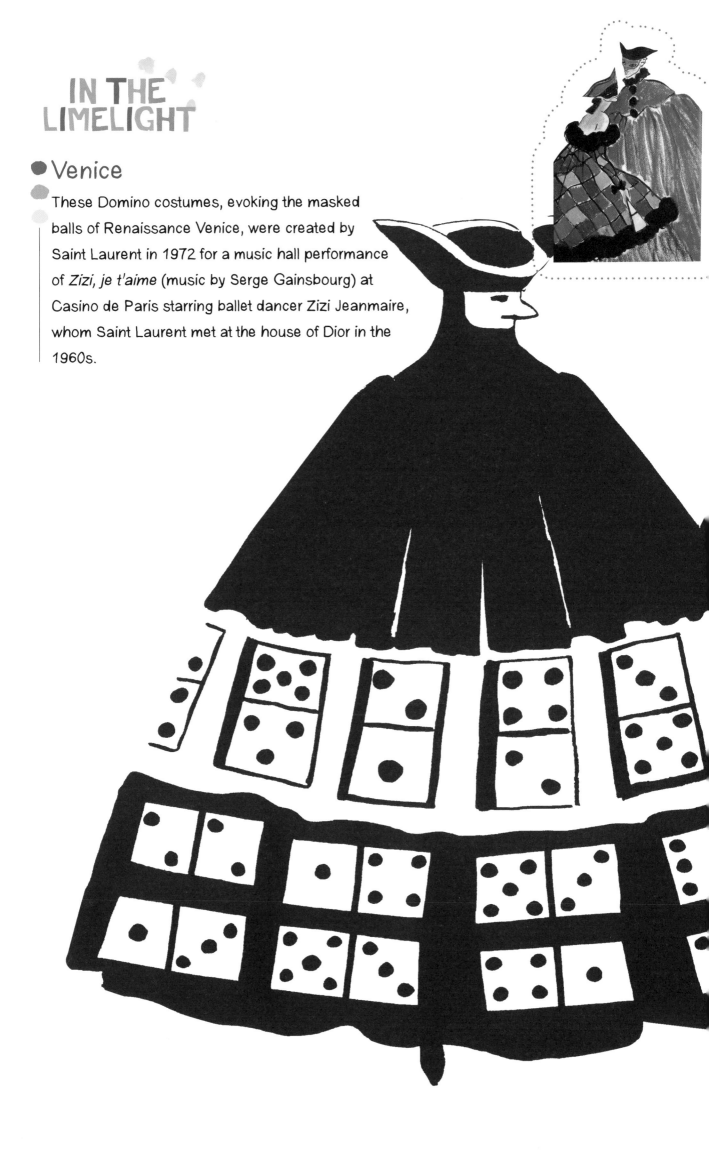

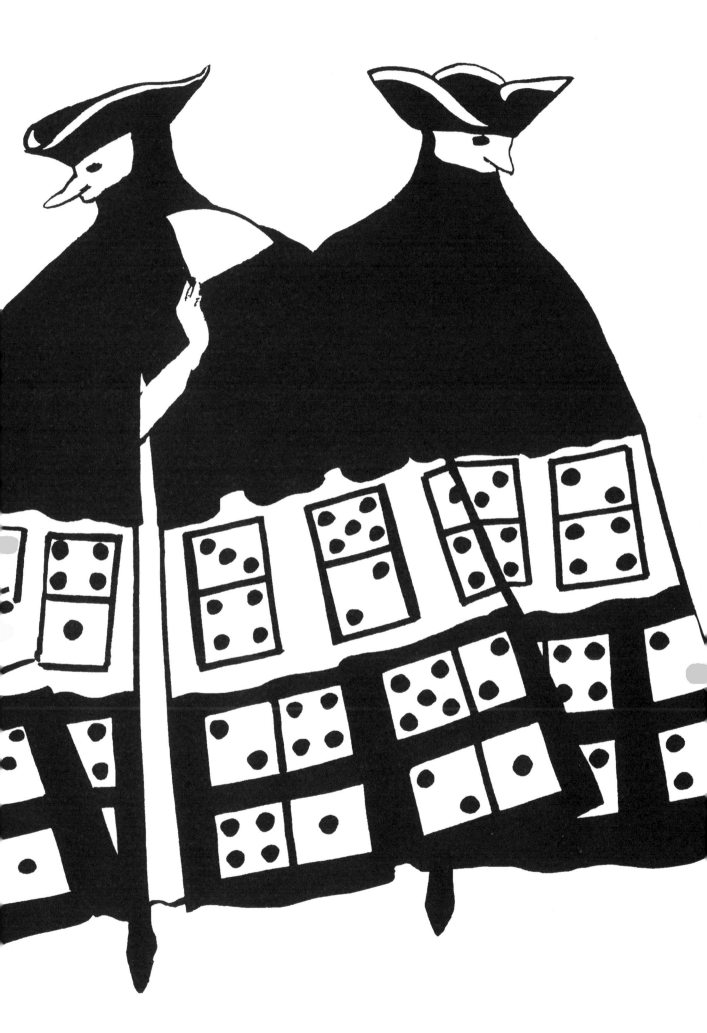

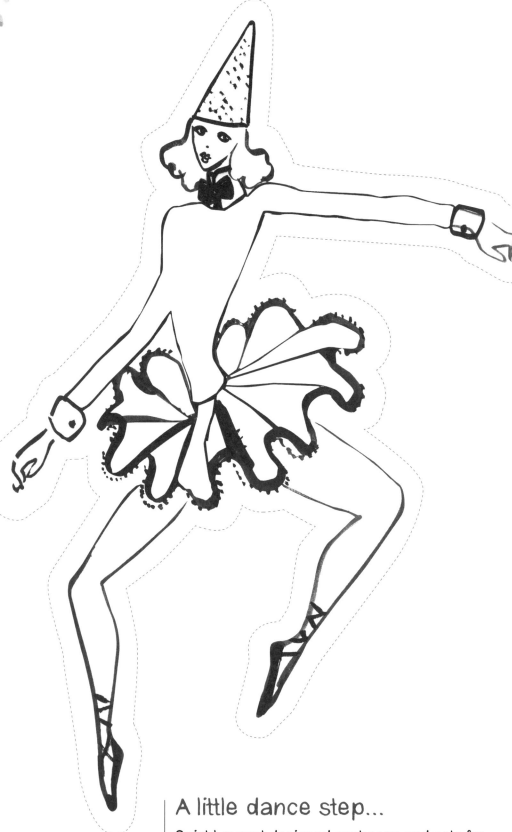

A little dance step...

Saint Laurent designed costumes and sets for
ballets and music—hall revues in the 1960s and '70
working with choreographer Roland Petit, dancers
Rudolf Nureyev, Margot Fonteyn, Maya Plisetskaya
Zizi Jeanmaire (wife of Petit), and others.

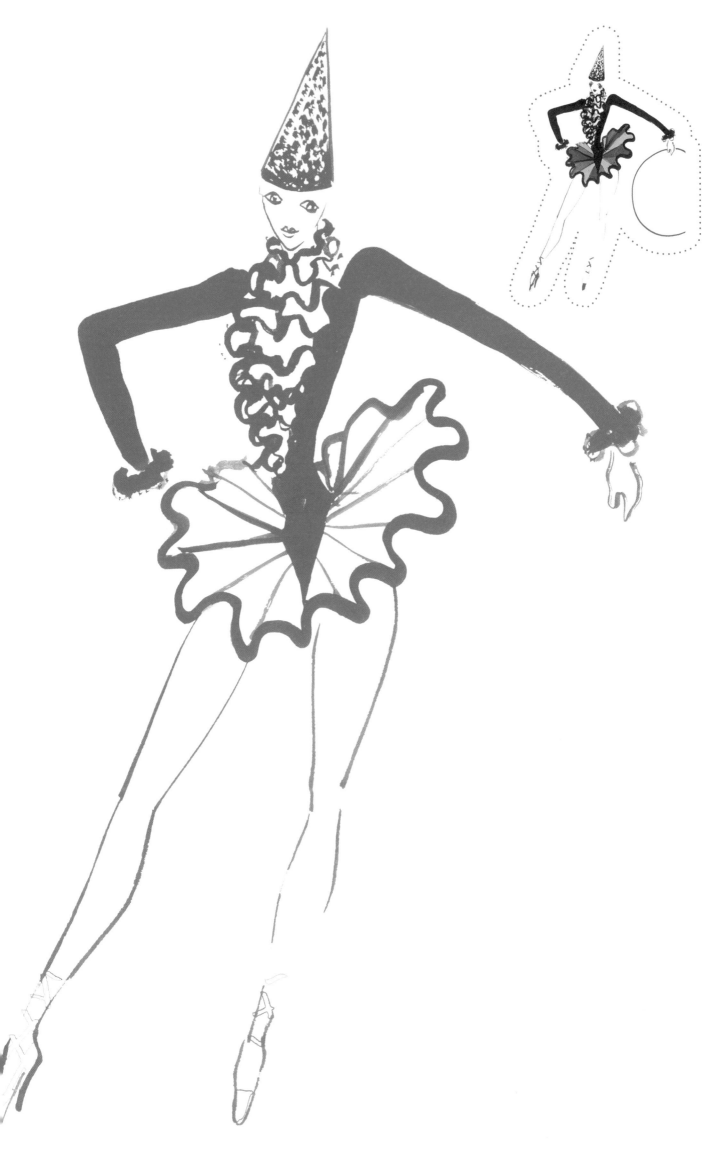

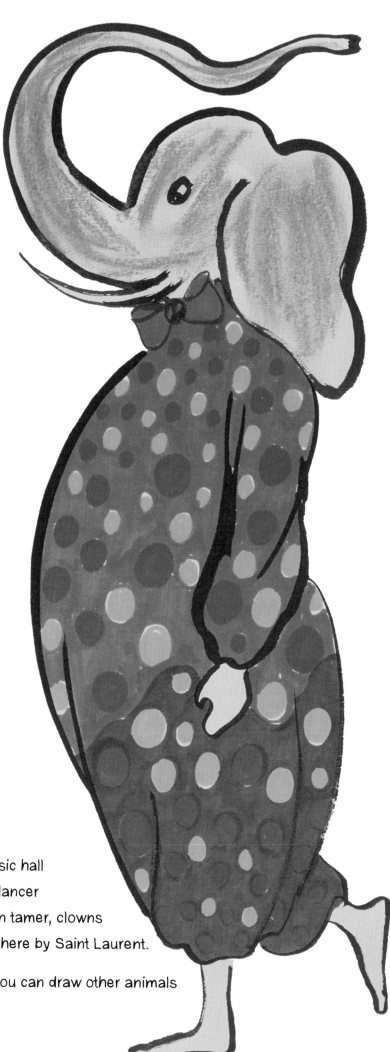

The Elephant Dance

The circus number in the 1972 music hall
spectacular *Zizi je t'aime* starring dancer
Zizi Jeanmaire featured lions, a lion tamer, clowns
and this playful elephant sketched here by Saint Laurent.

The page on the right is blank so you can draw other animals
for the circus troupe.

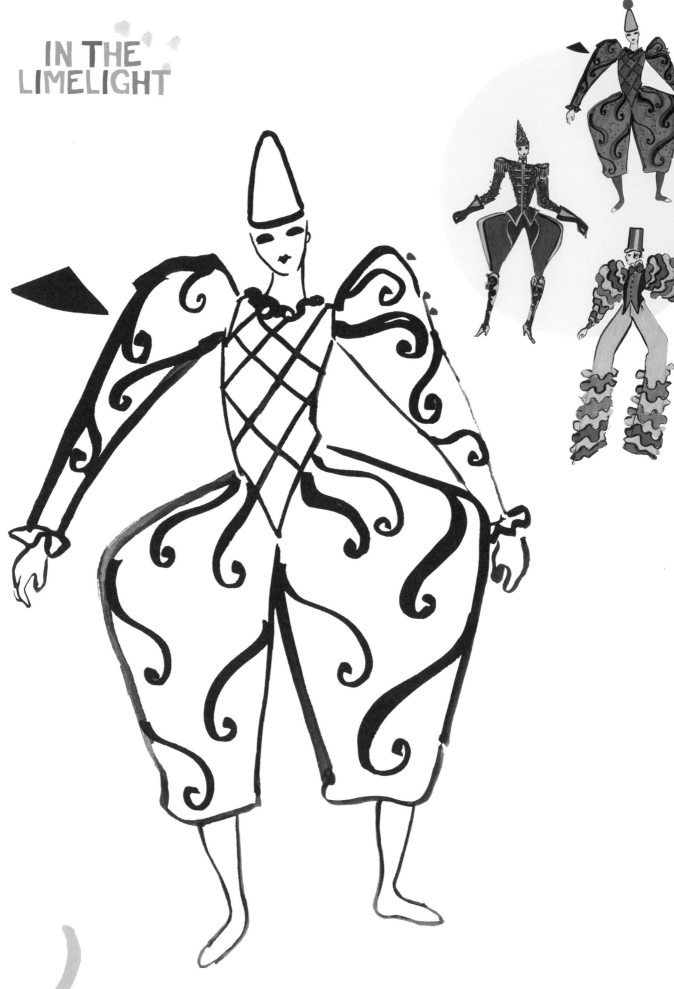

Send in the Clowns

Clowns and harlequins have appeared on stages around the world
since ancient Greece and are known in the plays of Shakespeare,
Commedia dell'arte, and, of course, in the circus.

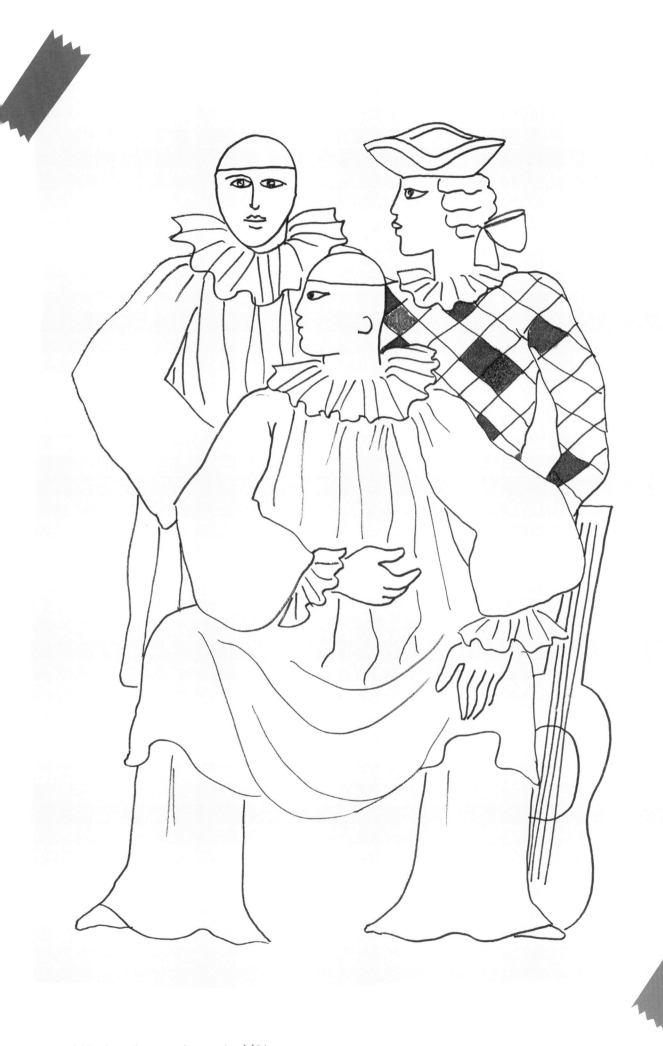

| Harlequins as drawn by YSL.

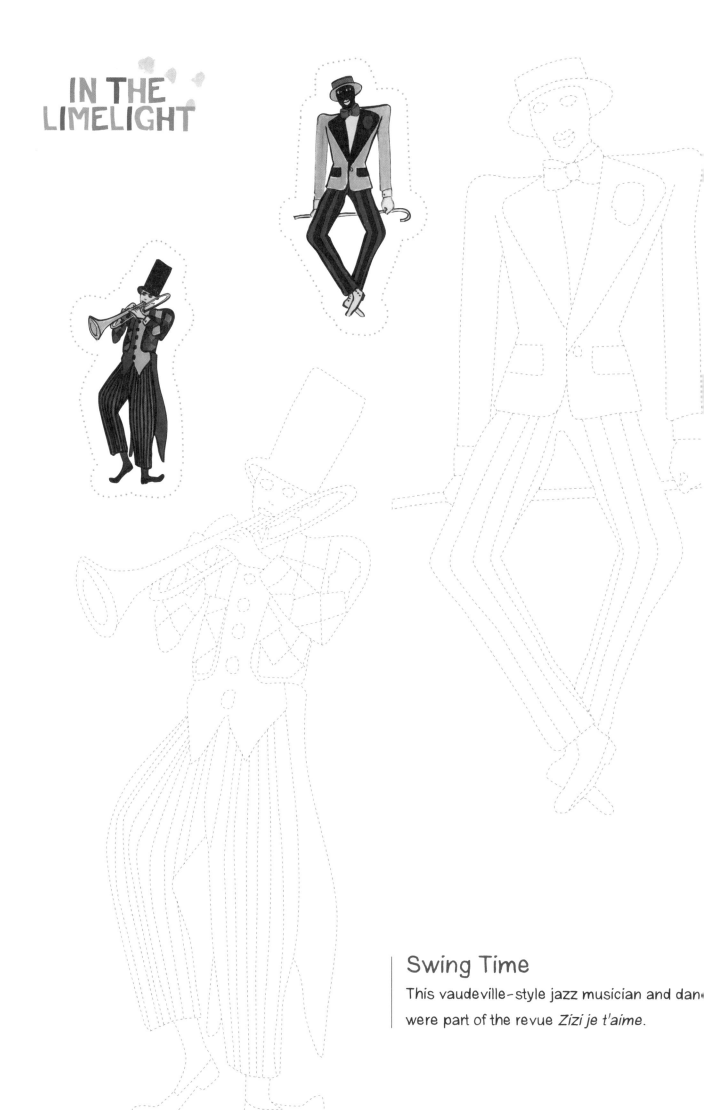

IN THE LIMELIGHT

Swing Time

This vaudeville-style jazz musician and dan‹
were part of the revue *Zizi je t'aime*.

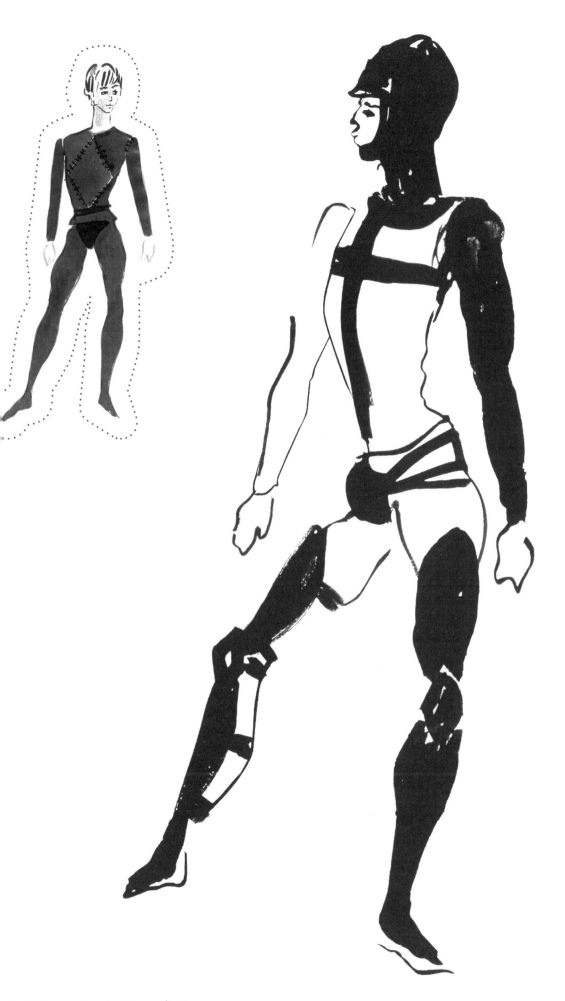

The Soldiers' Dance

Costume from the ballet *Notre Dame de Paris*, 1965, choreographed by Roland Petit.
These appear in the Soldiers' Dance scene. Saint Laurent said that he "wanted the
costumes [to be] as colorful as the stained-glass windows of a cathedral."

Raise the Curtain

Jean Cocteau's 1939 play *Les Monstres Sacrés* was reprised in Lyon in 1966 with all the costumes designed by Saint Laurent. The play starred Léonie Marie Julie Bathiat, known as Arletty, a French actress, singer, and fashion model. It was to be her last role.

Color in the stained glass window by following the designated numbers. When there is no indication use the color of your choice!

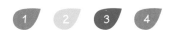

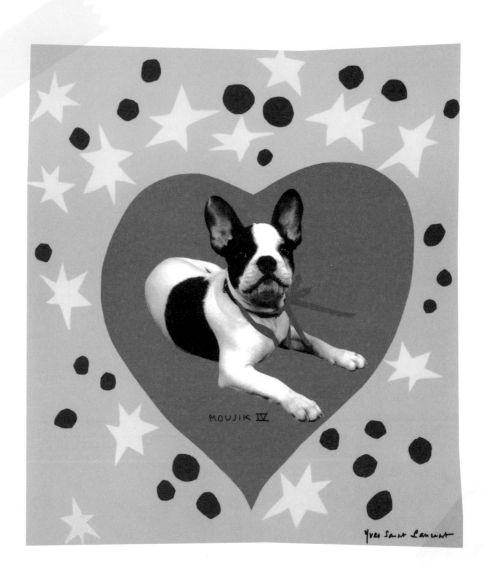

MOUJIK IV

Yves Saint Laurent